Carolyn Lanchner

Jasper Johns

The Museum of Modern Art, New York

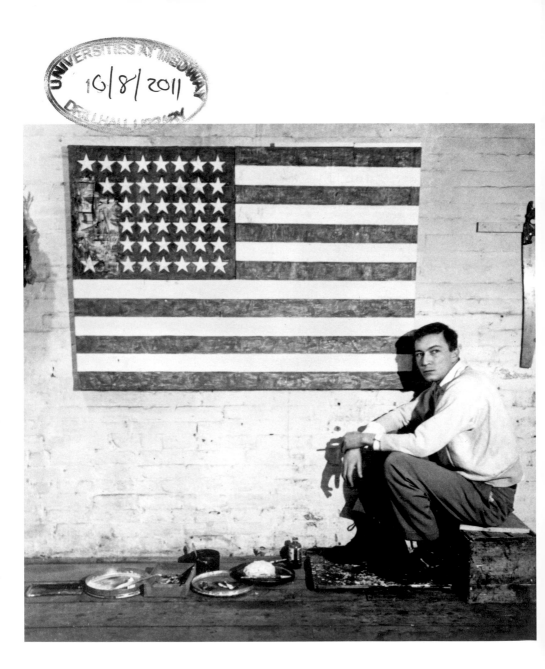

Jasper Johns in his Pearl Street studio with
Flag (1954–55), New York, 1955. Photograph
by Robert Rauschenberg. © 2009 Estate
of Robert Rauschenberg/Licensed by VAGA,
New York, N.Y.

This book presents ten works selected from over

four hundred pieces by Jasper Johns in the collection of The Museum of Modern Art. In 1958 the Museum acquired *Target with Four Faces* (discussed here on p. 8), *Green Target* (p. 13), and *White Numbers* (p. 15), introducing Johns's work into the collection and building the foundation for MoMA's strong representation of his paintings. Johns is a prolific printmaker, and the majority of his works in the collection are prints. The Museum began collecting them in 1961 and organized *Johns: Lithographs* in 1970 and *Jasper Johns: A Print Retrospective* in 1986. MoMA held two major exhibitions of the artist's work in 1996: *Jasper Johns: Process and Printmaking* and *Jasper Johns: A Retrospective*, a comprehensive survey. In the catalogue that accompanied the retrospective, curator Kirk Varnedoe made this summation of Johns's significance: "Johns changed the course of art in his time. . . . Beyond the well-recognized, immediate impact of the early paintings and sculptures, Johns has provided ongoing inspiration for generations of peers and younger artists." This book is one in a series featuring artists represented in depth in the Museum's collection.

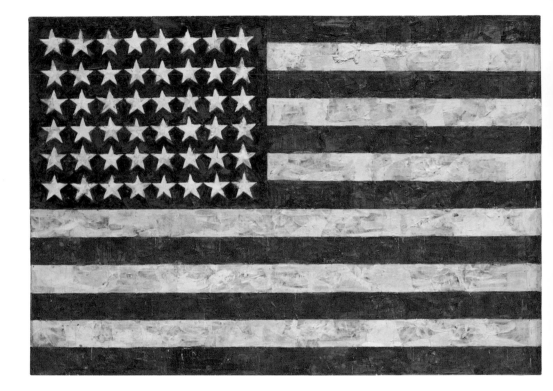

Flag 1954–55 (dated on reverse 1954)
Encaustic, oil, and collage on fabric mounted
on plywood, three panels, overall 42 ¼ x
60 ⅝" (107.3 x 153.8 cm)
The Museum of Modern Art, New York.
Gift of Philip Johnson in honor of Alfred H.
Barr, Jr., 1973

Flag (1954–55)

In late 1954 Jasper Johns destroyed virtually all of his previous work. He was twenty-four years old and had been living in New York since his discharge from the United States Army in May 1953. It was time, he remembers, "to stop *becoming* and *to be* an artist. . . . I had a wish to determine what I was. . . . what I wanted to do was find out what I did that other people didn't, what I was that other people weren't." The impetus for the picture that launched his career came from a source that was uniquely his: "One night I dreamed that I painted a large American flag, and the next morning I got up and I went out and bought the materials to begin it."

Flag was one of several paintings that delivered a still-memorable jolt to the art world during Johns's first solo exhibition, in New York in early 1958 at Leo Castelli's new gallery. Of all the puzzling pictures, *Flag*'s cool, painterly appropriation of the Stars and Stripes attracted particular scrutiny. It was, wrote Robert Rosenblum, "easily described as an accurate painted replica of the American flag, but . . . as hard to explain in its unsettling power as the reasonable illogicalities of a Duchamp readymade. Is it blasphemous or respectful, simple-minded or recondite?"

For Johns this icon of American identity was neutral, without polemic, whether political or aesthetic. Explaining his tactics, he said, "Using the design of the American flag took care of a great deal for me because I didn't have to design it. . . . That gave me room to work on other levels." So blandly familiar that our senses register it mechanically, it was the perfect subject for Johns's first full-fledged experiment in the relations between thought and sight. Putting things people had an everyday relationship with into the context of painting could, he believed, prompt a revitalized visual experience. *Flag* not only accomplished that mission, but it prompted critics to designate Johns, along with Robert Rauschenberg, an initiator of Pop art.

In displacing the American flag from life to art, Johns gave equal weight to subject and process. "The painting of a flag is always about a flag," he said, "but it is no more about a flag than it is about a brushstroke, or about a color or about the physicality of paint." In this instance, the slow-drying, dissolving qualities of oil paint drove Johns to encaustic, a medium that would become part of his signature style. Cooling quickly, the hot wax performed the yeoman task of collaging bits of newspaper to the canvas while leaving a cumulative record of its passage in a tactile, optically seductive film over the painting's otherwise dead-on stare. In another move to maneuver the flag from quotidian appurtenance to high art, Johns almost imperceptibly altered the wholeness of the image. To emphasize the painting as a three-dimensional object and stress the persistency of its flat surface pattern, the artist precisely constructed the support from three conjoined panels keyed to its model's compositional

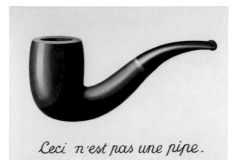

divisions—one for the stars and one for the stripes at the top, and a single horizontal for the stripes of the lower half of the picture. As for the stars against their blue field, Johns did all he could to neutralize their figure/ground effect, setting each star shape *in*, not *on*, the blue field. In brief, this is how the most well-known abstraction in the world was converted to representation.

Flag's equivocal status as representation has often been related to René Magritte's famously provocative 1929 painting of a pipe with *Ceci n'est pas une pipe* (This is not a pipe) written beneath it (fig. 1), a work Johns had seen in several versions at the Sidney Janis Gallery in New York in 1954. Magritte's painting points to the boundary between reality and illusion, while Johns's collapses their difference. Commenting on his own image, Magritte pointed out that it has no perceptible material thickness; Johns's *Flag* is three-dimensional, both object and emblem, picture and subject. In the late 1950s and early 1960s, when most critics were still trying to distinguish the means from the meaning in Johns's images, artist Donald Judd noticed the accommodating character of paintings like *Flag* in a "curious polarity and alliance of the materiality of objects and what is usually classed as the more essential qualities of paint and color. . . . 'Congruency' is a relevant description." At about the same

7

1 René Magritte (Belgian, 1898–1967)
La Trahison des images (Ceci n'est pas une pipe) 1929
Oil on canvas, 23 ¾ x 31 ¹⁵⁄₁₆ x 1 " (60.2 x 81.1 x 2.5 cm)

Los Angeles County Museum of Art. Purchased with funds provided by the Mr. and Mrs. William Preston Harrison Collection

time, Rosenblum switched from worrying himself with category questions to a delighted endorsement of the work, which, he said, "assaults and enlivens the mind and the eye with the exhilaration of discovery." That excitement of mind and eye was what Leo Steinberg meant in this summation of his brilliant 1962 analysis of Johns's works: "Seeing them becomes thinking."

Target with Four Faces (1955)

Once *Flag* was made, Johns followed its generative logic with targets—"things," as he famously said, "the mind already knows." Like their predecessor, the target paintings appropriate an instantly recognizable, already-made object—a nonabstract abstraction whose essential structure is flatness. Their differences in connotation and design are, however, considerable. The business of both flag and target is to focus attention, but the action of one is symbolic and tied to a specific culture, whereas that of the other is utilitarian and ubiquitously available. Without Johnsian interference, the flag instructs the mind to observe it ceremonially, while the target invites a stare of single, fixed intensity. However, once Johns had artfully compiled layers of newspaper and encaustic on their surfaces, they were delivered into the specialized zone of art, where both flag and target demand another sort of ritualized looking.

Under reprogrammed scrutiny, the shift from the allover linear patterning of *Flag* to the target paintings' hierarchical

Target with Four Faces 1955
Encaustic on newspaper and cloth over canvas surmounted by four tinted-plaster faces in wood box with hinged front,

overall, with box open, 33 ⁵/₈ x 26 x 3" (85.3 x 66 x 7.6 cm)
The Museum of Modern Art, New York.
Gift of Mr. and Mrs. Robert C. Scull, 1958

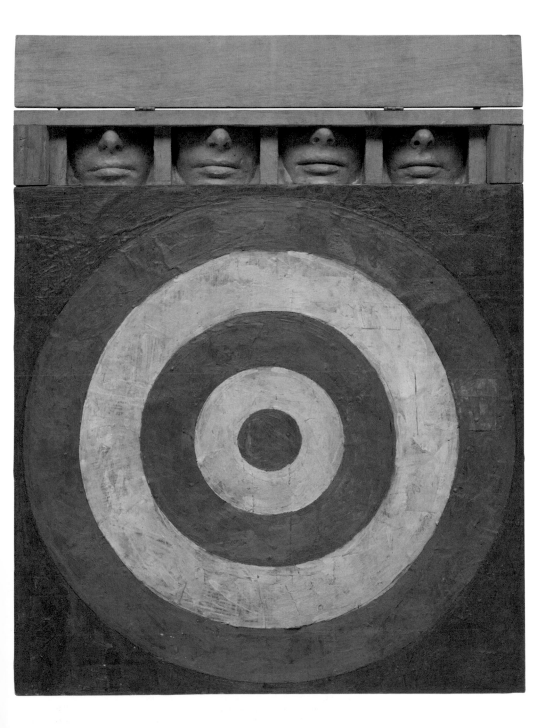

radial symmetry takes on formal significance. For the most part Johns diffused the latter's look of centralized organization through color and format. In the first two, *Target with Four Faces* and *Target with Plaster Casts* (fig. 2), concentric yellow and blue circles form an even layer with the rich red rectangle surrounding them. Vitiating figure/ground distinction, this conflation of the primaries melds the curvilinear and the linear with attention-getting effect. But as their factually impeccable titles specify, *Target with Plaster Casts* and *Target with Four Faces* are equipped with far more diversionary power than the merely pictorial. As John Russell politely remarked, the upper part of each "is really very peculiar." Referring to the odd curiosity cabinet with hinged door surmounting *Target with Plaster Casts*, Russell contrasts the shadowed depths of its three-dimensional recesses with the "light of open day which floods across the target." Writing in 1981, he declared that "the complete image, as haunting as any in twentieth-century art, has overtones of fairground and firing squad, jury box and old-style pharmacy."

2 *Target with Plaster Casts* 1955
Encaustic and collage on canvas with
painted plaster casts in wood box with
hinged front, overall 51 x 44 x 3 ⁷⁄₁₆"
(129.5 x 111.8 x 8.8 cm)
Collection David Geffen, Los Angeles

An array of variant readings of *Target with Four Faces* is loaded into its structure. One reading plays with our understanding that faces are the property of both people and targets. A target's face is normally seen at a distance in indistinguishable multiples and a human face close up, uniquely recognizable; here the target is brought into an enlarging proximity that blurs its identity, while the human face repeated in four nearly indistinguishable modules is distant, set in partitions higher than median eye level. Adding to this indefinably disturbing reversal of the expected is the painting's quirky focus on sight by way of blindness—in the dead stare of the bull's-eye and the impassive, eyeless heads above.

Ironically, *Target with Four Faces* became the most visible herald of the critical sensation Johns's first solo exhibition provoked. More or less coincident with the show's opening at the Leo Castelli Gallery in January 1958, *Art News* magazine put the picture on its cover and misleadingly labeled it "neo-Dada." Critics seized on the word and in indiscriminate, often contradictory ways loudly proposed Johns's hermetic, carefully planned art as the successor to Dada's rowdy, collective antics. Simultaneously and with more reason, discussion had it that this newcomer's unclassifiable work was an extension of, and an attack on, the mystique and the self-reflexive formal strategies of Abstract Expressionism. Artist Robert Morris understood Johns's insidious methodologies. He claimed that midcentury modernism, including Abstract Expressionism, had been "largely euthanized by Johns."

Green Target 1955
Encaustic on newspaper and cloth over
canvas, 60 x 60" (152.4 x 152.4 cm)
The Museum of Modern Art, New York.
Richard S. Zeisler Fund, 1958

Green Target (1955) In this, the first of

Johns's many monochrome targets, the subject virtually disappears within a dense, visually seductive mat of cloth, newspaper fragments, and other printed material bound together by uneven, sometimes transparent layers of pigmented wax. Before encountering it in a group exhibition in March 1957, fledgling dealer Leo Castelli had never seen a painting by Jasper Johns. Some two decades later he remembered the moment vividly: "I was thunderstruck. It was like the sensation you feel when you see a very beautiful girl for the first time, and after five minutes you want to ask her to marry you." Two days later, when Castelli showed up for a studio visit with Robert Rauschenberg, Johns's closest friend and upstairs neighbor, an opportunity to pop the question unexpectedly came about. When Castelli realized that the ice they needed for their drinks was to be fetched from the downstairs loft of "the one who had painted the green picture," the focus of his visit rather brutally shifted down a flight, initiating the dealer's lifelong partnership with Johns.

Less than a year later, immediately after the opening of Johns's first solo exhibition at Castelli's gallery in January 1958, Alfred H. Barr, Jr., of The Museum of Modern Art, showed his own fervor for the artist, choosing for the Museum's prestigious collection four paintings by, in Johns's own admission, an artist whom nobody had ever heard of. Barr had justifiable faith in his ability to move his acquisitions committee to buy *Green Target*, *Target with Four Faces* (1955) (p. 9), and *White Numbers* (1957) (p. 16), but fearing that the trustees might perceive *Flag* (1954–55) (p. 4) as unpatriotic, he persuaded architect Philip

Johnson to buy the painting for donation to the Museum at a later date.

For Barr's professional purposes *Flag* was odd man out in the group of four paintings he wanted, but, as he undoubtedly realized, the real deviant in the group is *Green Target*. The other paintings were, in Johns's own words, "very strongly objects," and the closer they seemed to things in the real world, the more they displayed familiar Duchampian qualities. The aesthetic function of a bottle rack (in fig. 3) or bicycle wheel (in fig. 4) is exchangeable with the utilitarian. Despite variant degrees of Johnsian bricolage, *Flag*, *Target with Four Faces*, and *White Numbers* are objects whose use value might be relocated. The flag could be saluted, the target shot at, and the numbers used as an oculist's chart—but *Green Target* is only marginally more useful for marksmanship practice than one of Ad Reinhardt's monochrome paintings (fig. 5).

14

White Numbers (1957)

In the latter half of the 1950s Johns expanded his range of subjects to include alphabets and numbers. He made *Gray Alphabets* (fig. 6), his first alphabet painting, in 1956 and followed it the next year with *White Numbers*. For each, Johns devised indeviant chartlike structures that impart an allover surface uniformity to the whole. At the same time, as Roberta Bernstein has observed, Johns's "painterly handling . . . transforms each unit into a 'unique painting within a painting.'" Except to solve structural questions, Johns rarely made preliminary drawings. He arrived at the format he would use in all his numbers paintings in *Sketch for Numbers* (fig. 7), a preparatory drawing for *White Numbers*. In that picture and its successors, the numerals 0 to 9 are set, as Johns scholar Nan Rosenthal has neatly described, "in horizontal and vertical rows of eleven digits each, leaving the first square on the upper left blank. Each row begins with a new numeral in sequential order so that a diagonal line from upper right to lower left bisects the nine in each row." The constraints Johns imposed

6 *Gray Alphabets* 1956
Encaustic on newspaper on canvas,
66 ⅛ x 48 ¾" (168 x 123.8 cm)
The Menil Collection, Houston

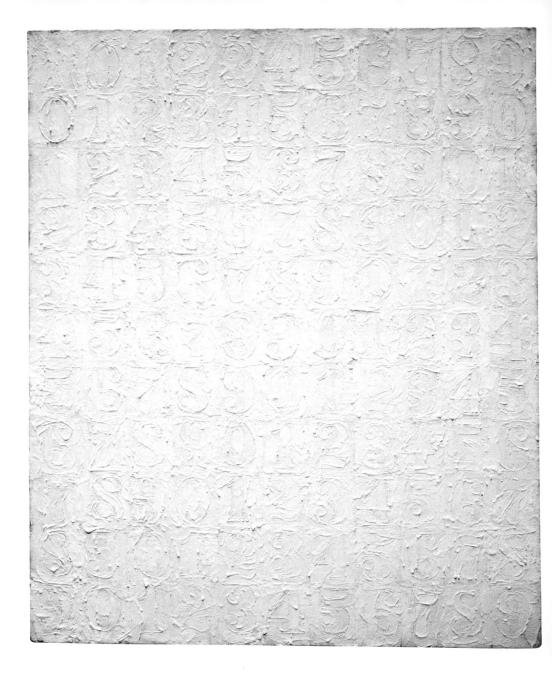

White Numbers 1957
Encaustic on canvas, 34 x 28 ⅛"
(86.5 x 71.3 cm)
The Museum of Modern Art, New York.
Elizabeth Bliss Parkinson Fund, 1958

upon himself in making *White Numbers* gave him a custom version of the freedom from aesthetic decisions he had derived from the fixed boundaries of the American flag. Effectively, he turned this small canvas into a staging ground for exquisite competitions—between structure and imagery, technique and subject, the whole and its parts.

The delicate film of ivory wax stretching edge to edge over *White Numbers* enfolds the painting in visual silence while simultaneously evoking a sense of embodiment and haptic appeal. It exemplifies the remark made by artist Frank Stella that Johns's work is "all surface," not painted but "coated" by an encaustic with a "colloidal" quality, "like skin." The year before he painted *White Numbers*, Johns had devised an equation of numbers and human presence in a series showing individual numbers on a rectangular field. At first he had intended to call them "numbers" paintings but switched to "figures," a pun that not only pleased him but gave him a chance he wanted—to have, "like de Kooning," his own figure paintings.

Typically, *White Numbers* toys with our perceptual mind/eye wiring. Its messily meticulous surface alternately seems as delicious as cookie dough and as fragile as a veil drawn over a dream—a curious fate for the numerals of decimal notation.

17

7 *Sketch for Numbers* 1957
Pencil on paper, 10 ⅜ x 8 ¼" (26.4 x 21 cm)
The Menil Collection, Houston. Bequest of David Whitney

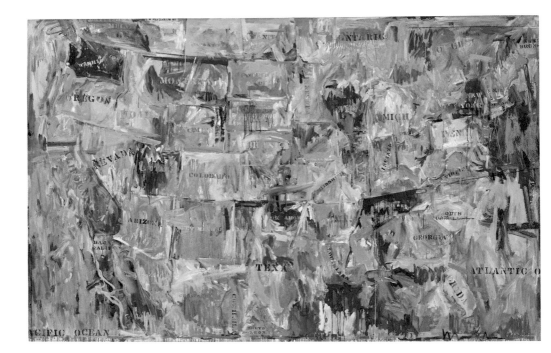

Map 1961
Oil on canvas, 6' 6" x 10' 3 ⅛"
(198.2 x 314.7 cm)
The Museum of Modern Art, New York.
Gift of Mr. and Mrs. Robert C. Scull, 1963

Map (1961)

The motif for this painting came ready-made and unexpectedly, the terms Johns has consistently preferred. In 1960 his close friend Robert Rauschenberg gave him some printed outline maps of the United States. For both men, as for every other American of their generation, the maps would have been instantly recognizable—just like the ones their childhood geography teachers had required them to fill in with color and the correct name of each state. Johns drew a grid on one of the maps and, transferring its coordinates to a canvas, began a vastly enlarged update of coloring and naming.

Finished, *Map* is scripted to attract multiple, elastically reversible sorts of reactions. Along with Marcel Duchamp, Johns believed that "the spectators . . . make the pictures." In the now vast spectatorship recorded in critical commentary, one of the most sensitive of lookers was the novelist Michael Crichton, who located Johns's pictures somewhere "between Duchamp and Pollock, between the found object and the created abstraction." If *Map*'s "found-objectness" can include Proustian memories of an American childhood while simultaneously allowing its assertive, Abstract Expressionist brushwork to be compared, as Leo Steinberg did, to "the way Cézanne used to paint, in broken planes composed of adjacent values," then Crichton has provided a useful, capacious space for seeing Johns.

The schoolroom map was never intended as an aid for navigating the American continent, but like other maps it can be read to establish the intervals between states, the Canadian and Mexican borders, which states face the Atlantic or the Pacific, and which have straight-line boundaries. While *Map* solicits

questions like these, its allover visual strategies mute their urgency. In general, the picture treats Abstract Expressionism's gestural rhetoric as a collection of use-dedicated devices ready to be remade in a work where viewing will take priority over making. Most immediately eye-catching are the hot and cool bursts of yellow, red, and blue activating *Map*'s surface from edge to edge. These apparently freely brushed clusters of oil paint are nearly as controlled as the encaustic Johns carefully layered over his earlier flags, targets, and numbers. If the brushy passages in *Map* seem specifically De Kooning–esque, it is because that artist's signature marks had become emblematic of Abstract Expressionist "action painting." Not quite hidden in their pastiched proliferation across *Map*'s surface, a patch of peachy paint in the upper left-hand corner is so authentically like its model that it may be a hat's-off gesture to the master, whom Johns greatly admired.

Much as Johns's earlier single-number paintings linguistically appropriate Willem de Kooning's "figures" for digital fairing and truing, this map offers a cooled-down alternative to the apocalyptic landscapes implicit in Jackson Pollock's visionary abstractions of 1949 and 1950. It was with pictures like those that Pollock, as De Kooning famously put it, "broke the ice" for the rest of them. De Kooning's meaning was not, as interpretation has sometimes had it, that Pollock broke new pictorial ground, but that he had created the first American painting to crack international indifference. About ten years later, Johns may or may not have been intentionally punning when he literally put American painting on the map.

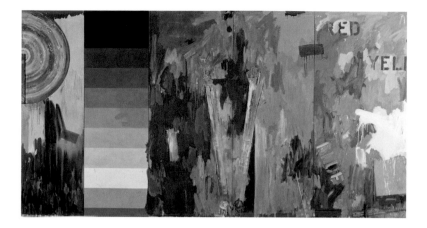

Diver (1962–63) Around 1961 the mood of

Johns's work became darker, more personal. In the words of Kirk Varnedoe, it had become "an art under pressure, and imagery of imprinting and smearing . . . gave it a more troubled material and psychological life." The year he completed this drawing Johns assessed his earlier work as more "intellectual," whereas with his new pictures, he said, the viewer "responds directly to the physical situation," effectively showing the work to be "more related to feeling or . . . emotional or erotic content." For the immediate affective power the artist spoke of, *Diver* is virtually unrivaled within the body of Johns's work.

Begun modestly as a "diagram" for the two central panels in the monumental painting *Diver* (fig. 8), of the previous year, this huge drawing emerged some months later possessed of its own commanding presence. Despite its initial conception in the *Diver* painting, the drawing's arrival in the world is most intimately connected to *Periscope (Hart Crane)* (1963). Hanging side by side on a studio wall, the two works received the

21

8 *Diver* 1962
Oil on canvas with objects, five panels,
overall 7' 6" x 14' 2" (228.6 x 431.8 cm)
Collection Norman and Irma Braman

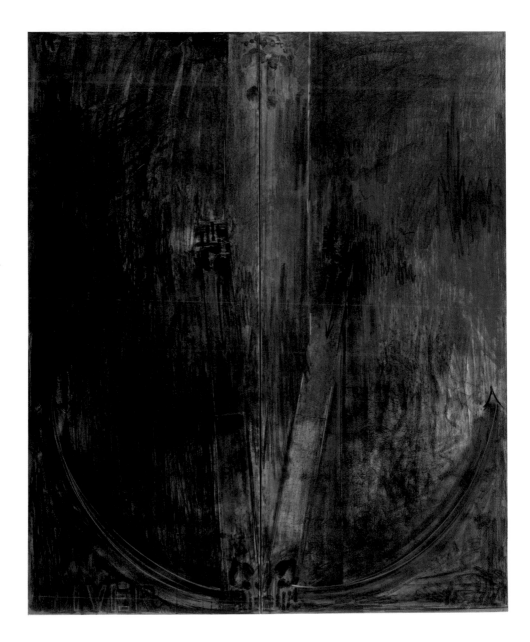

Diver 1962–63
Charcoal, pastel, and watercolor on
paper mounted on canvas, two panels,
7' 2 ½" x 71 ¾" (219.7 x 182.2 cm)
The Museum of Modern Art, New York.
Partial gift of Kate Ganz and Tony Ganz in
memory of their parents, Victor and
Sally Ganz, and in memory of Kirk Varnedoe;
Mrs. John Hay Whitney Bequest Fund;
gift of Edgar Kaufmann, Jr. (by exchange);
and purchase. Acquired by the Trustees of
The Museum of Modern Art in memory
of Kirk Varnedoe, 2003

attention of their creator alternately (figs. 9 and 10). Completed, *Periscope* declares itself a commemoration of the poet Hart Crane, who dove to his death from a ship in 1932. Its title comes from Crane's poem "Cape Hatteras," part four of *The Bridge* (1930), in which "a periscope" glimpses "joys or pain" then shunts "to a labyrinth submersed." Although there is no explicit connection, the artist has confirmed that the drawing, too, can be related to Crane. In the knowledge that Johns read Crane extensively, it is tempting to associate the drawing's palette to the "chimney-sooted heart of man" in his poem "Passage" (1925) and its structure, earthbound as it is, to Crane's line, in the same work, "The evening was a spear in the ravine/that throve through the very oak."

The drawing divides into two panels so tightly aligned that the artist's left footprint at the top spreads across their division. The clean line cleaving the densely worked charcoals and pastels of its light and dark surface caused David Sylvester to say that the drawing looked as though "Rembrandt had been at work on a Barnett Newman." The parallel bands whose division reminded Sylvester of a Newman "zip," or stripe, less likely represent a diving board, as has often been posited, than the body of the diver displaying the soles of his feet in his downward plunge. Johns has said that the work represents the idea of a swan dive. Given that the drawing pictures an idea, it is not surprising that the rules of the dive are asynchronically observed by Johns's performer. Every position of the body points to the moment of entry into the water, yet the arrow-topped arcs radiating out from the touching hands direct the arms to stretch

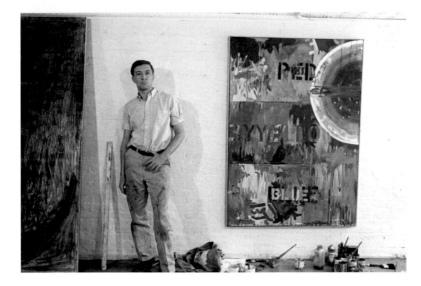

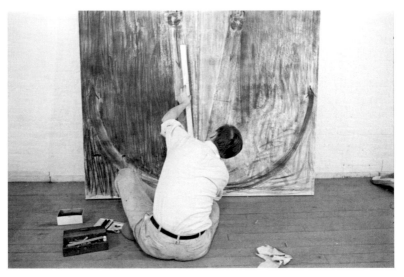

9 and 10 Johns in his Front Street studio working on *Diver* and *Periscope (Hart Crane)*, above, and *Diver*, below, New York, 1963. Paul Katz Archive, Department of Image Collection, National Gallery of Art Library, Washington, D.C.

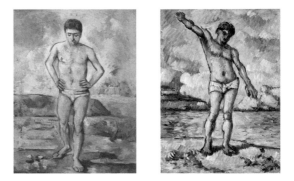

sideways in the stance properly timed with the initial leap into the air. While the imprint of the artist's hands on the upper and lower ends of the rigid strips of the diver's arms may be read symbolically as raised in exultation or lamentation, primarily they suggest movement opposite to the dive. An arrow pointing down to a hingelike line bisecting each arm suggests that they can be bent when, at last, the submerged diver must, in a phrase from Crane, "delve upward" toward the air.

More than the dead poet, Johns himself is implicated in this lonely fall through space. Several observers have found connections between *Diver* and Paul Cézanne's painting *The Bather* of around 1885 (fig. 11), a work of primary importance for Johns. If the artists' family names were switched, Theodore Reff's description of *The Bather* as a "projection of Cézanne himself, . . . of his own solitary condition," would equally apply to *Diver*. In another reversible equation, *Diver* is eerily possessed of a "synaesthetic quality. . . [that] makes looking equivalent to touching," which Johns vividly remembers from his first encounter with *The Bather*. The sensation he felt then is now daily renewable in a small variant of *The Bather* presently in his own collection (fig. 12).

A devotee of what Crane called the "dynamics of inferential mention," Johns surely knew that his picture of a swan dive

11 Paul Cézanne (French, 1839–1906)
The Bather c. 1885
Oil on canvas, 50 x 38 ⅛" (127 x 96.8 cm)
The Museum of Modern Art, New York.
Lillie P. Bliss Collection, 1934

12 Paul Cézanne (French, 1839–1906)
Bather with Outstretched Arms 1883–85
Oil on canvas, 13 x 9 ⁷⁄₁₆" (33 x 24 cm)
Collection Jasper Johns

might also be received as a swan song—a final performance or a farewell to an artistic period. In the former, emphasized by the skull-like appearance of the hands at the base of the drawing, the diver is the one who dies. In the latter he is an artist suspended between what he has made and what he will make. It should be added that Johns has left ample room for other interpretations.

Between the Clock and the Bed (1981)

This is one of three monumental paintings of the same title that mark the end of a decade devoted to abstractions of systematized, allover patterns of crosshatching. Depicting nothing nameable other than the brushstrokes that define their surfaces, these canvases are often equipped with titles suggesting sensory, emotional content. In this instance, the title is Norwegian artist Edvard Munch's for a 1940–42 self-portrait (fig. 13). Painted shortly before his death, Munch's picture shows the artist in his bedroom doorway, poised between emblems of mortality, death, and life—to the left, a handless clock; to the right, his bed; and on the wall a painting of a nude woman. However this symbolism may have accorded with Johns's mood, he knew the picture only through the seren-dipitous arrival of a postcard from a friend who had noticed the resemblance of the quilt on the bed in the painting to Johns's crosshatching. As for the hatching motif itself, Johns says he first saw it on a car glimpsed fleetingly as it sped by him on a highway.

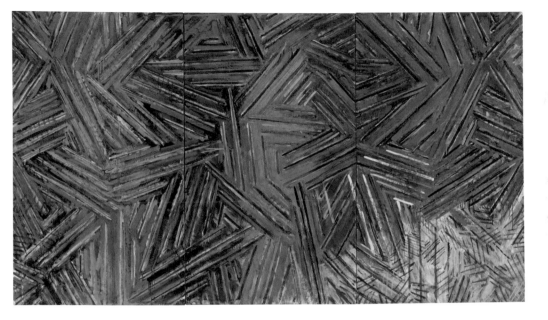

Between the Clock and the Bed 1981
Encaustic on canvas, three panels,
6' 1/8" x 10' 6 3/8" (183.2 x 321 cm)
The Museum of Modern Art, New York.
Gift of Agnes Gund, 1982

Johns's subsequent handling of the instantaneously absorbed motif was for the most part as meticulous as it is here. The painting divides vertically into three equal panels with the patterns in the outer sections set up as mirror images of each other. The hatch marks in the middle section align with the interior edges of the side panels in a linear flow on the left and an elbowed bend at the right. In the lower-right corner Johns created, in the words of Nan Rosenthal, "a triangular area of incident . . . with short extra hatch marks . . . in primary colors on a pale ground," showing that "a layer of primaries lies beneath the violet, orange, and green that predominate."

A particularly vibrant, ghost-glowing orange consolidates a group of crosshatchings into a single, vertical unit in the middle of the picture. Upright between its flanking panels, Johns's "figure" reads as an abstract double of Munch's image of himself standing between clock and bed, its coverlet evoked in the schematized area of primaries at the lower right. This overt play with older art is a defining characteristic of the whole suite of crosshatched works. More than anything Johns had yet done, they exemplify his notion of painting "as a conversation with oneself" that is simultaneously "a conversation with other paintings." *Scent*, of 1973–74, named after one of Jackson Pollock's last paintings, was the first to extend

13 Edvard Munch (Norwegian, 1863–1944)
*Self-Portrait: Between the Clock and
the Bed* 1940–42
Oil on canvas, 58 ⅞ x 47 ⁷/₁₆" (149.5 x 120.5 cm)
Munch Museum, Oslo

14 *Weeping Woman* 1975
Encaustic and collage on canvas,
50 x 8' 6 ¼" (127 x 259.7 cm)
Collection David Geffen, Los Angeles

the abstract patterns of Johns's crosshatching into an allover con-figuration designed to modify and comment on Pollock's legacy. Another painting by Johns that addresses a major player in twentieth-century art is the triptych *Weeping Women* of 1975 (fig. 14), which nominally refers to the series of that title Picasso made in connection with *Guernica* in 1937. Although Johns's *Weeping Women* displays a violence of mark-making that brings it close to the 1937 Picasso, its most immediate references are to the 1907–08 nudes—*Dance of the Veils* (fig. 15), for example—that obsessively occupied the older artist on completion of *Les Demoiselles d'Avignon* in 1907.

　　　Rosalind Krauss's observation that the "crude and insistent hatching" of Picasso's post-*Demoiselles* period "declared that the language for depicting depth was to be the major problematic of modern style" is modestly matched by Johns. With infinite finesse—in pictures such as *Between the Clock and the Bed*—he retooled the hatch mark, converting it from a sign signifying a turn into depth to an abstract trajectory inscribing the planarity of its support. In so doing he devised a singular sort of abstraction, neither geometric nor gestural but combining aspects of both.

29

15　Pablo Picasso (Spanish, 1881–1973)
Dance of the Veils 1907
Oil on canvas, 60 x 39 ¾" (152 x 101 cm)
State Hermitage Museum, St. Petersburg

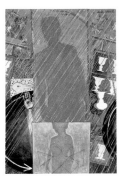

Summer (1985)

In the mid-1980s Johns turned away from his long involvement with abstraction toward works of oblique narrative replete with allusions to his own past. *Summer*, the first in a series of four paintings playing on the ancient theme of the revolving seasons (with figs. 16, 17, and 18), was not begun, Johns says, with such extended ambition. Rather, the idea "to commission himself" to take on the project was sparked by Wallace Stevens's 1923 poem "The Snow Man." Implicitly written in the first person, the poem proposes a witness to the cyclical return of "the sound of the land/Full of the same wind/That is blowing in the same bare place." Like *Summer*, each painting in the Seasons series shows Johns's life-size shadow surveying time's passage in an accrual of his art and his possessions.

Johns's ghostly self-portrait dominating each of the Seasons paintings was inspired by Picasso's image of himself in *The Shadow* (fig. 19), an especially haunting painting of 1953. There, darkly profiled against the light, the seventy-two-year-old artist shows himself contemplating his bed, where in memory he sees the nude body of the young mistress who has just left him. Unmistakably evocative of Picasso, Johns's figure is both closer to and more distanced from himself than is the older artist's to his

30

16 *Fall* 1986
Encaustic on canvas, 6' 3" x 50"
(190.5 x 127 cm)
Collection the artist

17 *Winter* 1986
Encaustic on canvas, 6' 3" x 50"
(190.5 x 127 cm)
Private collection

18 *Spring* 1986
Encaustic on canvas, 6' 3" x 50"
(190.5 x 127 cm)
Robert and Jane Meyerhoff Collection,
Phoenix, Maryland

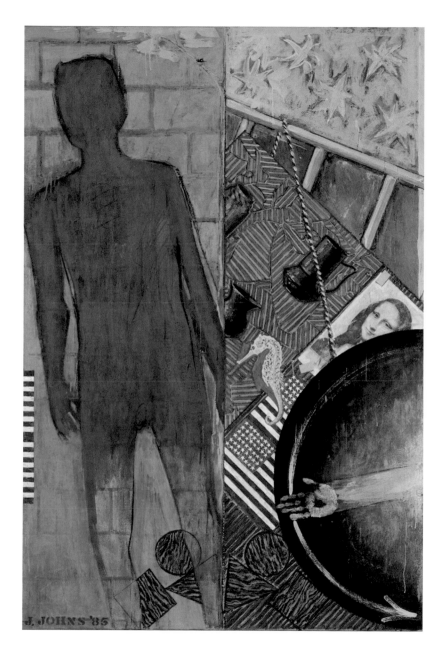

Summer 1985
Encaustic on canvas, 6' 3" x 50"
(190.5 x 127 cm)
The Museum of Modern Art, New York.
Gift of Philip Johnson, 1998

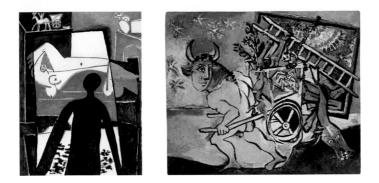

own persona. Where Picasso imagined his replica directly with paint on canvas, Johns began with his own body. He had a friend trace his shadow as he stood in the sun; the result served as a template for transfer to canvas. The hesitant tilt of his outlined image is no less affective than Picasso's, even if obtained by a specialized bit of mechanical drawing. In his appropriations from another Picasso, *Minotaur Moving His House* of 1936 (fig. 20), Johns put aside mediating strategies. In the midst of a great deal of moving himself, he found the Minotaur painting more interesting for its subject than for its structure: "The catalogue of things is very layered. . . . And, of course, it was very odd to see the cart before the horse . . . and on it is a horse giving birth. . . . Very wonderful, very interesting in an unexpected way. . . . How did he have that thought? I wouldn't have had that thought." Johns provided each of his Seasons with an animated background of stars like those presiding over the Minotaur's cart and also equipped them with its contents: a rope, ladder, canvas, and tree branch. *Summer*, displaying his own version of an odd thought, represents Picasso's large horse in parturient agony by a small, exquisite sea horse, one of the few species in which the male bears offspring.

Although differently disposed, the picture within a picture in each of the Seasons paintings displays objects symbolizing

32

19 Pablo Picasso (Spanish, 1001–1973)
The Shadow 1953
Oil and charcoal on canvas, 49 ½ x 38"
(125.7 x 96.5 cm)
Musée Picasso, Paris

20 Pablo Picasso (Spanish, 1881 1973)
Minotaur Moving His House 1936
Oil on canvas, 18 ⅛ x 21 ⅝" (46 x 54.9 cm)
Private collection

various stages of Johns's career on a ground whose jigsaw linear patterning more than adequately conceals a harrowingly diseased figure from Matthias Grünewald's *Temptation of Saint Anthony* of around 1512–16 (fig. 21), ubiquitous in Johns's work at the time. Appearing in *Summer*'s interior picture are stacked American flags and a print of the *Mona Lisa* collaged to its support with trompe l'oeil tape. Both were recurrent motifs in Johns's most recent painting, and the iconography of each reverberates across his career: the flag, for the art world, at least, equivalent with the artist himself, and the *Mona Lisa* simultaneously emblematic of Leonardo da Vinci and Marcel Duchamp, two artists Johns had decades earlier singled out as of the greatest interest to him.

Apart from Johns's shadow, the most distinctive image in all four allegorical paintings is the arm/handprint inscribing a half-circle that links them directly to *Diver* of 1962–63 (p. 22). Here the black half-sphere swept by the gray imprint of the artist's left arm and hand carries darker implications than its predecessor in *Diver*. There the device symbolizes suspension, a delay in the resolution of a blind plunge. In the Seasons paintings it suggests the implacable operation of a clock. With each painting the hand rotates and Johns's shadow responds, shifting positions with the passage of time through the four cycles of the year and, cumulatively, four stages of life.

33

21 Matthias Grünewald (German, c. 1475–1528)
Temptation of Saint Anthony (detail). Panel from the Isenheim Altarpiece c. 1512–16
Oil on wood panel, 8'9" x 6'9 ½"
(269 x 207 cm)
Musée D'Unterlinden, Colmar, France

Untitled (1992–95)

Johns undertook this exceptionally large, ambitious painting in his sixty-fifth year, at the beginning of his fifth decade as an artist. Having pointed out these biographical facts in the essay he wrote for The Museum of Modern Art's 1996 Johns retrospective, Kirk Varnedoe observed of this untitled work, "To describe this image is to probe archaeologically back down forty years of his art." On the most straightforward level, the picture's horizontal format divided in three vertical sections reflects a painting Johns executed some ten years earlier (fig. 22). Dematerialized beneath a filtering layer of newer motifs, the words RED, YELLOW, and BLUE, fields of circles, and a plunging directional arrow are visible traces of their 1984 model. By then, however, their lineage could already be traced back to works such as Diver (p. 22) and Periscope (Hart Crane) of 1963 (fig. 9). In turn, the half-circles in those paintings are linked to Device Circle of 1959 (fig. 23), itself extrapolated from Johns's earliest images of targets.

Onto what Varnedoe called "this already stratified foundation of reversal and multiple reprise," Johns added layers of more recent imagery. The large gray cross on the right was derived from a 1990 etching combining a child's silhouette, a ladder, and the artist's shadow, all from his autobiographical Seasons series of 1985–86 (pp. 30–31). A further, incomplete

34

22 Untitled (Red, Yellow, Blue) 1984
Encaustic on canvas, three panels, overall
55 ¼" x 9' 10 ½" (140.3 x 300.9 cm)
The Museum of Fine Arts, Houston. Gift of
The Brown Foundation, Inc.

23 Device Circle 1959
Encaustic and collage on canvas with wood,
40 x 40" (101.6 x 101.6 cm)
Collection Denise and Andrew Saul

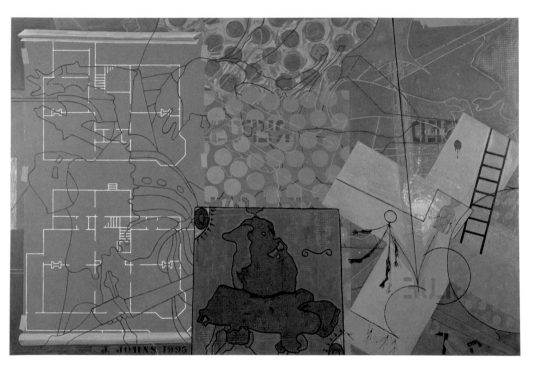

Untitled 1992–95
Oil on canvas, 6' 6" x 9' 10"
(198.1 x 299.7 cm)
The Museum of Modern Art, New York.
Promised gift of Agnes Gund, 1995

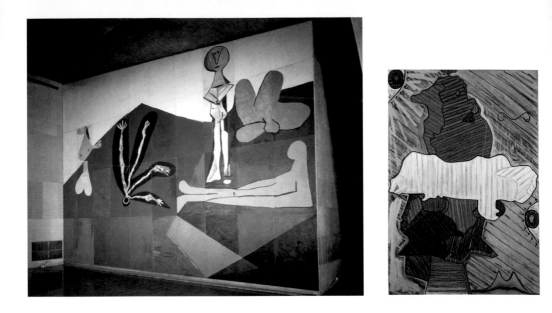

inventory of motifs superimposed on the cross might include a stick figure with a globular head, a quote from *Fall of Icarus* of 1958 (fig. 24), a Picasso image Johns began using in 1992; three smaller stick figures that had been making appearances for about a decade; a whirling galaxy, a recent addition to the artist's pictorial lexicon; and, above it, to the right, a small splatter of paint, a long-familiar mark referring, among other associations, to the accidents of spontaneity in painting and to the ejaculatory spatterings in Marcel Duchamp's 1915–23 artwork *The Bride Stripped Bare by Her Bachelors, Even (The Large Glass)*.

 The lower center of the canvas holds an exquisitely painted picture within a picture in a variety of deep hues. Overall, the image is a variant on an untitled painting of 1990 (fig. 25) that combines a rectangular face adapted from an idiosyncratically surreal Picasso—*The Straw Hat with Blue Leaves* of 1936 (fig. 26)—with a puzzlelike motif based on a tracing of an object. Johns

36

24 Pablo Picasso (Spanish, 1881–1973)
Fall of Icarus 1958
Mural composition, 26' 2¹⁵⁄₁₆" x 32' 9¹¹⁄₁₆"
(8 x 10 m)
Lobby of the Delegates, UNESCO
Headquarters, Paris

25 *Untitled* 1990
Oil on canvas, 6' 3" x 50" (190.5 x 127 cm)
Collection the artist

has declined to identify. Finally, the left third of the canvas is covered by a floor plan of Johns's grandfather's house in South Carolina, where the artist spent most of his childhood. In a pastiche of trompe l'oeil illusionism, the plan presents itself as a blueprint, unfurled and taped along its edges. Traced over its surface and carrying across the upper half of the picture is a motif that had frequently appeared in Johns's work since 1982: a linear tracing of a falling soldier based on one of the surprised guardians of Christ's tomb in Matthias Grünewald's *Resurrection* panel in the Isenheim Altarpiece of around 1512–16 (fig. 27).

The foregoing by no means exhausts the potential for archaeological excavation in this untitled work. The picture's meaning is not, however, to be gleaned from cataloguing its recognizable elements, but from their synthesis. Weaving together disparate motifs, this grand picture is a key, as Varnedoe discerned, "to the conundrums of picture making and the concerns with time, memory, personal history, and art history that continue to absorb the changing focus of Johns's eye."

37

26 Pablo Picasso (Spanish, 1881–1973) *The Straw Hat with Blue Leaves* 1936 Oil on canvas, 24 x 19" (61 x 48.3 cm) Musée Picasso, Paris

27 Matthias Grünewald (German, c. 1475–1528) *Resurrection* (detail). Panel from the Isenheim Altarpiece c. 1512–16 Oil on wood panel, 8'9" x 6'9 ½" (269 x 207 cm) Musée D'Unterlinden, Colmar, France

Bushbaby (2003) "It's important that one sees
the instability of what one is looking at—that it could be changed.
I like that you're aware of other possibilities, whether you wish
to set them in motion or not." When Johns made this statement
he was referring to his Catenary paintings—*Bridge* of 1997 (fig.
28), for example—in which the curve of a piece of string across a
canvas surface can be varied each time the hooks suspending it
are moved. This invitation to viewer participation—unlikely to be
tolerated in any museum or collection—has a long history in
Johns's art, going back to the hinged compartments of his target
paintings of 1955 (pp. 9 and 10). In *Bushbaby* the prominence of
the wing nut holding the wooden struts in a tense, uncertain
balance makes its readjustment proposition especially provocative.

Juxtaposed with the undisguised suggestion of future
change is a record of the variable process of its making. Exquisitely
executed in Johns's beloved encaustic, the painting's surface
preserves the gesture of his hand, thus allowing the beholder
access to the decisions that have gone into its making. Very early
on, the artist's close friend John Cage grasped the implications
of a Johns surface as "an objective correlative for change."
Although Cage had in mind a painting from 1955, the words he

39

Bushbaby 2003
Encaustic on canvas with wood bars, metal
fittings, and string, 66 ⅛ x 43 ¹⁵⁄₁₆ x 3 ⅜"
(168 x 110 x 9 cm)
The Museum of Modern Art, New York.
Promised gift of the Donald L. Bryant, Jr.,
Family Trust, 2005

28 *Bridge* 1997
Oil on canvas with objects, 6' 6" x 8' 9" x
7 ⅝" (198.1 x 299.7 x 19.3 cm)
Promised gift of an anonymous donor to the
San Francisco Museum of Modern Art

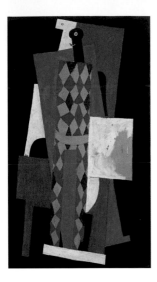

used to describe its effects—"forming and melting, tightening and loosening, appearing and disappearing"—apply equally to *Bushbaby*. On the left the brightly colored constellation of circles seems to melt into the sides of the wood slats, and at the upper right the tight interlacing of triangles in a Harlequin pattern loosens and melts as they move diagonally toward the bottom, while in the center they appear and disappear under a delicate film of gray encaustic.

An abstraction filled with representational clues, the painting is something of a tease. The mirror image of its central section in the adjacent gray area is, as in many of Johns's paintings, a device open to interpretive looking. More than one observer has seen echoes of Picasso's 1915 painting *Harlequin* (fig. 29) in its configurations. Although Johns says he was not thinking of Picasso when working on *Bushbaby*, he does concede that the Spanish artist was a strong presence in *Pyre* and *Pyre 2* (figs. 30 and 31), the two paintings directly preceding it, and

29 Pablo Picasso (Spanish, 1881–1973)
Harlequin 1915
Oil on canvas, 6' ¼" x 41 ⅜" (183.5 x 105.1 cm)
The Museum of Modern Art, New York.
Acquired through the Lillie P. Bliss Bequest,
1950

that "a residue" may have carried over. In both of those paintings, what looks like a floor at the bottom also looks very much (when rotated ninety degrees) like Picasso's *Harlequin*—even to the irregularities of its diamond patterning and the belt crossing the body. Although *Bushbaby* prominently displays a similar pattern, its units are symmetrical. The most direct carry-over from its immediate precursors seems to be the double-mound shape at their lower-right edges, which may be read as shoes. Reappearing in *Bushbaby* as an extension of the black vertical Johns intended to suggest a figure on the left, the shape might recall shoes or assume an anatomical connotation. Independent of the two earlier paintings, *Bushbaby*'s strongest evocation of Picasso's figure is in the implied shifting of the vertical slats in association with the semighostly appearance of Harlequin's motley. The felt sensation of planes on the very edge of tilting delivered by the Picasso assumes real-life potential in the Johns.

41

30 *Pyre* 2003
Encaustic on canvas and wood with objects,
66 ½ x 44 ⅛ x 2 ⅛" (168.9 x 112.1 x 5.4 cm)
The Museum of Modern Art, New York.
Fractional and promised gift of
Marie-Josée and Henry R. Kravis, 2006

31 *Pyre 2* 2003
Oil on canvas and wood with objects,
66 ¼ x 44 x 6 ¾" (168.3 x 111.8 x 17.1 cm)
The Museum of Modern Art, New York.
Fractional and promised gift of
Marie-Josée and Henry R. Kravis, 2006

Lastly—and quite off the Picasso track—why does the painting carry the name of a tiny nocturnal African animal? Not because Johns had the creature itself in mind, but rather, he has indicated, for its associations to a being obscured by bush. If Picasso does not figure in this line of thought, perhaps Marcel Duchamp does. Johns has said that he likes Duchamp's idea that a title should be like another color in the work.

Jasper Johns in his studio on East Houston
Street, New York, June 1973. Photograph by
Nancy Crampton. © 2009 Nancy Crampton

Jasper Johns

was born in Augusta, Georgia, in 1930 and spent his childhood in South Carolina. Beginning at age seventeen he studied art for short periods at University of South Carolina and Parsons School of Design, New York, then was drafted into the Army in 1951. After his return to Manhattan two years later, Johns met three men who would profoundly influence his thinking: artist Robert Rauschenberg, composer John Cage, and choreographer Merce Cunningham.

In 1955, with a deceptively straightforward painting of the American flag, Johns initiated a new style based on quotidian imagery, or, as he has said, on "things the mind already knows." In his first solo exhibition, in 1958, Johns's "ready-made" motifs startled critics used to the gestural panache and strident subjectivity of the previous generation. His targets, flags, and numbers cooly co-opt Abstract Expressionism's allover compositional techniques and rhetorical brushwork, but their use in his work demonstrates conscious control rather than spontaneity.

A combination of private reference and public engagement has been at the center of Johns's art from its beginnings. As he became well known, his motifs came less from public icons than from a variety of things he had seen, glimpsed in passing, studied in past art, or otherwise held in memory. His concern with process is evidenced in the printmaking that has engaged him since 1960; he is critically ranked as one of history's greatest printmakers. Johns's work is widely recognized as instrumental to the development of Pop, Minimal, and Conceptual art in the 1960s and as a catalyst to various other art movements up to the present day. He lives and works in Connecticut and St. Martin.

Produced by
The Department of Publications,
The Museum of Modern Art, New York

Edited by Rebecca Roberts
Designed by Amanda Washburn and
Beverly Joel
Production by Elisa Frohlich

Printed and bound by Oceanic
Graphic Printing, Inc., China
Typeset in Avenir
Printed on 140 gsm Gold East Matte
Artpaper

Library of Congress Catalogue Card
Number: 2009935192
ISBN: 978-0-87070-768-1

Published by
The Museum of Modern Art
11 West 53 Street
New York, New York 10019-5497
www.moma.org

Distributed in the United States
and Canada by
D.A.P./Distributed Art Publishers, Inc.
155 Sixth Avenue, 2nd Floor
New York, New York 10013
www.artbook.com

Distributed outside the
United States and Canada by
Thames & Hudson, Ltd.
181 High Holborn
London WC1V 7QX
www.thamesandhudson.com

Printed in China

Photograph Credits

All works by Jasper Johns © 2009 Jasper Johns/Licensed by VAGA, New York, N.Y.

© 2009 Estate of Marcel Duchamp/Artists Rights Society (ARS), New York/ADAGP, Paris: 14 (left and middle); © 2009 C. Herscovici, London/Artists Rights Society (ARS), New York: 7; © 2009 Paul Katz: 24 (top and bottom); © 2009 The Munch Museum/The Munch-Ellingsen Group/Artists Rights Society (ARS), New York: 28 (left); © 2009 Estate of Pablo Picasso/Artists Rights Society (ARS), New York: 29, 32 (left and right), 36 (left and right), 40; © 2009 Estate of Ad Reinhardt/Artists Rights Society (ARS), New York: 14 (right)

Courtesy Archives Succession Picasso: 32 (right); Department of Imaging Services, The Museum of Modern Art, New York, Thomas Griesel: 9, 27, 31, Kate Keller: 13, 16, 40, Paige Knight: 18, 22, 25 (left), Mali Olatunji: 14 (middle), John Wronn: 4; Paul Katz: 24 (top and bottom); courtesy Museum Associates/LACMA: 7; courtesy Philadelphia Museum of Art: 30; courtesy Réunion des Musées Nationaux/Art Resource, N.Y.: 32 (left and right); courtesy Réunion des Musées Nationaux/Art Resource, N.Y. Photograph by J. G. Berizzi: 36 (right); Hickey Robertson, Houston: 15; Graydon Wood: 30 (left)